CONTENTS

FOREWORD

This exhibition, concerning itself with the photograph as a printed object, has been conceived in the same spirit as *The Mechanised Image* which toured Britain in 1978 and sought to distinguish in printmaking one technique from another. This present anthology traces the development and use of photographic printmaking techniques from the 19th century up to the present.

The exhibition has been selected by Gerry Badger, a practising photographer and photographic historian, who has also written the catalogue. We thank him and the many lenders, listed separately, both in Europe and the United States, without whose generous support this exhibition would not have been possible.

JOANNA DREW, DIRECTOR OF ART

ACKNOWLEDGEMENTS

SELECTOR'S NOTE

Exhibitions such as this are born out of the efforts of many people, numerous conversations, letters, books, and hours of looking at works. They encompass many individual perspectives, and may change direction as well as shape before the public sees them. This exhibition is no different.

Of the many who have helped me with their time, insights, advice and support, I should like to thank the following: Pat Van Pelt and Jane Chisholm of the Arts Council of Great Britain: Mark Haworth-Booth, Victoria and Albert Museum, London: Valerie Lloyd, Royal Photographic Society, Bath: Richard Hough, Scottish Photography Group, Edinburgh: David Dawson, David Dawson Ltd, London: Leslie Waddington, Waddington Galleries Ltd, London: Nigel Greenwood, Nigel Greenwood Inc, London: Robert Self, London: John Benton-Harris, London: Alain Paviot, Galerie Octant, Paris: Anthony Shearman, Librarian, Central Library, Edinburgh.

Weston Naef, Metropolitan Museum of Art, NYC: Peter C. Bunnell, Princeton University, Princeton, NJ: Susan Kismaric and staff, Museum of Modern Art, NYC: Marianne Fulton Margolis, IMP/GEH, Rochester, NY: David Travis and staff, Art Institute of Chicago, Ill: Roy Flukinger and staff, Gernsheim Collection, University of Texas, Austin, Texas: Peter Briggs, University Art Museum, University of New Mexico, Albuquerque, NM: Mr and Mrs James L. Enyeart, Tucson, Ariz: Sherri Denton, Center for Creative Photography, Tucson, Ariz: Richard Pare, Seagram Collection, NYC: Janet Lehr, Janet Lehr Inc, NYC: Daniel Wolf and staff, Daniel Wolf Inc, NYC: Lee Witkin and staff, Lee Witkin Inc, NYC: Charles Traub, Light Gallery, NYC: Marvin Hiefermann, Castelli Graphics Inc, NYC: Joan and Nathan Lyons and staff, Visual Studies Workshop, Rochester, NY: Bea Nettles, Rochester, NY: Judith Natal, Rochester, NY: Harry Lunn and staff, Harry Lunn/Graphics International Inc, Washington DC: Kathleen Ewing, Kathleen Ewing Gallery, Washington DC: Joyce Tenneson Cohen, Washington DC: Betty Hahn, Albuquerque, NM: Joel-Peter Witkin, Albuquerque, NM: Todd Walker, Tucson, Ariz: William G. Larsen, Tucson, Ariz: Harold Jones III, Tucson, Ariz: David Fahey and staff, G. Ray Hawkins Gallery, Los Angeles, Calif: Stephen White, Los Angeles, Calif, plus all those individuals and institutions who have kindly lent works to the exhibition.

Lastly, I would like to accord a special mention of thanks to Barry Lane and Michael Regan of the Arts Council of Great Britain, for their unstinting efforts on my behalf, and Sam Wagstaff of New York City for his provocative enthusiasm.

Although we seem to have been inundated with exhibitions of photography in the past decade, the majority of these have been *of* photographs rather than *about* photography. One has difficulty in recollecting more than two major surveys of the latter kind. These were the Camden Arts Centre's *Photography Into Art*, an examination of the cross-currents between photography and painting, and the Photographer's Gallery's *Concerning Photography*, Jonathan Bayer's admirable attempt to grasp some of the medium's formal issues.

This present exhibition is concerned with the techniques of photography, and the various ways in which they have been utilised, since the medium's beginnings, to express the visions of photographers.

The exhibition deals primarily with the photograph as a print-object, and therefore inevitably concentrates upon those who consider themselves, or have been considered 'art' photographers. However, this is only a small, if persuasive and insistent part of the medium. Therefore, we shall refer to other areas of activity, such as mass media reproduction, or the use of the photograph for wider socio-political purposes, or the adaptation of photographic techniques by those foraging over the border from the traditional arts.

No exhibition such as this can be wholly comprehensive, and there are areas which are perhaps less well served than they deserve to be. Technique, after all, is only the servant of vision. This survey, therefore, is not so much an objective, encyclopaedic catalogue of techniques, but a subjective anthology of some of the achievements of photographic printmaking.

GERRY BADGER, JUNE 1981

PHOTOGRAPHER AS PRINTMAKER

→ PHOTOGRAPHER AS PRINTMAKER

140 YEARS OF PHOTOGRAPHIC PRINTMAKING

→ ARTS COUNCIL
OF GREAT BRITAIN

TOUR
Ferens Art Gallery, Hull
5 – 30 August 1981

Museum and Art Gallery, Leicester
16 September – 18 October 1981

Showing unconfirmed at time of printing
28 October – 28 November 1981

The Cooper Gallery, Barnsley
19 December 1981 – 17 January 1982

Castle Museum, Nottingham
30 January – 28 February 1982

The Photographers' Gallery, London
11 March – 11 April

© Arts Council of Great Britain 1981
ISBN 0 7287 0294 0

Exhibition organised by Michael Regan
assisted by Jane Chisholm
Education Liaison Pat Van Pelt

Printed by Belmont Press, Northampton

Front cover: Joel-Peter Witkin: *Mother (with Retractor, Screaming) and Child*, 1979.
(See catalogue entry No. 137.)

→ A FLEXIBLE FRAMEWORK

'The universally held characterisation of the photographer is that he is an observer, that he possesses a vision. In addition to this tenet there is the less realised fact that the photographer is also a printmaker – whether working with paper, metal or plastic, whether in terms of the unique original image or in multiples, whether through customary direct techniques, or synthetics, or combinations. Not all of the photographers who possess vision impart equal sensitivity in printmaking.'[1]

PETER C. BUNNELL

The preceding thoughts were voiced by Peter Bunnell in 1968, in an introduction to an exhibition he had organised for the Museum of Modern Art in New York. Entitled *Photography as Printmaking*, this exhibition was perhaps the first to deal with what was a fairly neglected consideration, both within and without strictly photographic circles.

Photographic printmaking remains generally neglected even though during the twelve years or so since that exhibition of Bunnell's we have witnessed a greatly increased interest in photography as a viable means of creative expression. The print still is taken somewhat for granted, even by photographers themselves with the result that the level of connoisseurship of the photographic print, as opposed to the photographic image remains relatively low.

One might inquire why a distinction, a conceptual separation need be made at all between image and print – that is to say between image and medium? In no other area of the graphic arts does one encounter such a differentiation, whether initiated by critics or by practitioners. We do not consider the subject of a painting completely independently from the physical way it has been put down on the canvas. Yet photographic critics, and photographers, seem locked into blinkered patterns of thought that find them capable only of dealing with concept without technique, or technique without concept.

In the traditional arts, image and medium are one – indivisible, interlocked, interdependent, inviolate. The image is the medium. The medium is

the message. However, the perennial dilemma that has dogged most commentators upon photography has been deciding just exactly what the medium is. Is the photographic medium those apparently magical, voluptuous light rays that transmit, almost unmediated, a fragment of the world from one existence to another? Or is it the flat, sensitised paper surface – the print? Or, putting the whole question another way, does the photographer concern himself with merely recording the world, interfering as little as possible, or reconstructing and reconstituting it, in the manner of the traditional artist?

Historically, as the fact of this dichotomy might suggest, there have been two more or less opposed camps. At least, that has been the generally prevalent view. It has been assumed in the main that proponents of these two approaches have agreed to differ. A lot of noise has been made regarding this great philosophical divide, but it has been largely ineffectual noise, fully reflecting the phoney nature of the war. For the gulf has not been quite as clear cut as has been thought; more practised in the manner than in the observance.

The war itself might be phoney, but attitudes none the less have become deeply entrenched. Thus it is necessary at least to define the old orders before perhaps establishing a new. The two schools of thought may be characterised by their relationship to the parent graphic medium from which in essence photography derives – that is to say, painting. The adherents of school number one seek total autonomy from the progenitor. They seek to define the pure photographic medium, borrowing nothing from, nor owing anything to painting. Photography is seen as a unique phenomenon, with its own very special,

not-to-be-tainted virtues. Those from school number two, however, fully embrace the painterly arts, and in the case of the *Fin de Siècle* movement of Pictorialism, actively denied pure 'photographic' values in favour of giving their work the look and values of painting.

Each 'school' has tended to be known by a variety of terms, but in the main imagery derived from the followers of precept number one has been termed 'straight' photography, while that derived from the second attitude has been termed 'experimental' photography.

The straight photograph may be defined as documentary in one way or another, and the straight photographer is obliged to interfere as little as possible with the mechanical process of making the picture, particularly during the printing stage.

Conceptually he or she might exercise what can be regarded as a 'vision'. Choice of viewpoint, timing, lighting, focal length of lens, even control of the negative's development are allowable manipulations. Anything goes, in fact, as long as it is non-manual, and *prior to printmaking*. Then, in the strict purist sense, only a minimal amount of density control, necessary for balancing any extreme tonal contrast in the print, can be tolerated.

Thus the purist, 'straight' philosophy confines photographer control to choice of subject-matter and the mechanical faculties of the camera, rather than the craft agencies of printmaking.

In opposition to the puritanical hegemony of straight photography, the experimentalists support a thoroughly hedonistic *laissez faire*. Anything goes, any kind of manipulation is urged, whether in or out of the darkroom, whether with or without the

[1] Peter C. Bunnell. *Photography as Printmaking*. Wall label for Museum of Modern Art, New York exhibition, March 19 – May 26, 1968. Page 1.

camera, whether incorporating purely chemico-mechanical means or manually produced elements. The final result may even strain to the utmost our conception of what is definable as photography. Such a distinction is of little import to the experimentalist, who, as one of the leading contemporary exponents, Jerry Uelsmann, points out,[2] is often a multi-media artist, with concerns beyond the narrow boundaries of photography – in painting, design, graphics, or sculpture. The finished product is of major importance. Although to say that is not to deny the fact that the process, the means, is a primary source of delight and ambition for many of these latter-day 'alchemists'.

Such are the traditional critical boundaries that seek to categorise what photographers are doing. Those on one side of this boundary concentrate upon the image, those, on the other, upon the medium. Or, as Peter Bunnell put it,[3] the one group seeks to make the medium invisible, the other seeks to make it visible.

As I have intimated, the rather ridiculous nature of the rift should be apparent from the most cursory glance at the history of photography from the most obvious examination of photographic *practice*, rather than photographic *theory*. Any photographer wishing to obtain an image that is easily viewable, in the hand and without the necessity for mechanical viewing equipment, is obliged to engage, however rudimentarily, in the process of printmaking. And in so doing, there must be a degree of conscious, manual interference with the fixed, objective impression of camera and film.

In our own time, the demands of the mass-media has encouraged many documentary and what we might term journeymen photographers to regard printmaking as an unwarranted interference, a tiresome necessity, a barrier between themselves and the almost unmediated vision of life. And they take steps to preclude this process as much as possible, by employing the professional equivalent of 'sending their snaps to the chemists'. The print is thus reduced to a relatively insignificant part of the whole operation, a factor which in itself is likely to mean that only a fraction of the negative's potential may be realised.

1. Jerry Uelsmann: *Untitled*, 1969

[2] Jerry N. Uelsmann. Ibid.

[3] Peter C. Bunnell. Op. cit.

Having said this, one can also find, throughout the history of the medium, unexpected examples of superlative printmaking by photographers who might not have seemed to be concerned in the slightest with expressing their vision in this manner. Take for example the prints of Walker Evans. Evans who is seen by many as almost the epitome of the 'straight' documentary ethic, yet his negatives are surprisingly fragile in printmaking terms. A really outstanding print from an Evans negative is a rarity rather than a commonplace. One might ask if an outstanding print from an Evans negative is really necessary? Well, Evans thought they were, and if he could be said to have been a somewhat erratic printer, once one has seen an outstanding print compared with lesser examples by Evans,

as in *Main Street, Saratoga Springs*, one can more readily understand what is meant by a photographic image – documentary or not – singing its song.

What becomes clear as one delves into the subtleties and mysteries of printmaking is that it is dangerous to make distinctions between takers and makers of photographs. Such distinctions are part of a redundant though tenacious concept that bears little upon the realities of photographic practice, whether or not by self-styled photographic artists or the representatives of the ordinary profession.

If we now throw the traditional critical postures into the melting-pot, we face one major problem. How should we look at and make sense of the diverse and inchoate mass of material that

can be represented as photographic printmaking?

Well, photography has always had a close, continuing, and reciprocal relationship with painting. In the various 'mixed-media' fields, where both photographic and manual graphic techniques are utilised, the distinction between what is 'photographic' and what is 'painting/drawing' is irredeemably blurred. So, in place of the traditional split between 'straight' and 'experimental' photographers, I would propose instead to view a work in relationship to its qualities of 'painterliness' and 'photographicness'.

The new critical edifice is erected as quickly and as simply as that. The complex issues involved in photographic printmaking can be largely resolved if we view the medium as a continuum, running from the 'pure' application of photographic technique and vision at one end, to the 'impure' hybrids of mixed-media at the other.

That this view of the medium might differ from the traditional schisms can be put to the test by selecting an example – that of the photogram. The photogram is an image made by transmitting light through translucent objects and exposing the resultant patterns on photographic paper. It was one of the earliest forms of photography, and it was a form of imagemaking much practised by the Dadaists and Surrealists amongst others. This Surreal connection has led to the photogram being considered 'experimental', and 'painterly', particularly as photogram imagery tends to look rather abstract and cubist.

Yet, fundamentally, the photogram is one of the purist and most direct of photographic processes, involving less intermediate manipulation than a 'straight' print from a conventionally made negative. Thus in purely technical terms a photogram might be located at the 'photographic' end of the spectrum. However, as we add conceptual criteria to the technical, the picture does become more complicated. A photogram of a feather or a flower by one of the early pioneers, such as Fox Talbot or Herschel, might be considered wholly photographic, in both technique and concept. Whereas the *'Schadographs'* of Christian Schad, or the *'Rayograms'* or Man Ray come from an entirely different conceptual root, and if photographically 'pure' in technique, are almost entirely painterly in aesthetic terms.

On the other hand, if we consider Walker Evans once more, his prints can

2. Walker Evans: *Main Street, Saratoga Springs*, 1931

3. A. L. Coburn: *Vortograph no. 8*

be seen as that of a rigorous purist. Evans was apparently attempting to create as transparent a window upon the world as possible, yet his extremely sophisticated treatment of the picture plane demonstrates a keen awareness of painterly concepts of space and composition, spatial effects organised by the mind of Evans, in conjunction with the machine.

Many of the images in this exhibition will not slip so easily into any one fixed position along the photographic/painterly continuum. What is more, images that hitherto have been considered as occupying different sides of the theoretical fence begin to connect with each other. No longer do we need to maintain a system that promotes discord, opposition, and inflexibility – that predisposes one to take a stance. In its place we have a flexible framework that reflects the real complexity of the medium, that in its allowance for slipping and sliding reflects photography's real ambiguities and contradictions, the medium's borrowings from traditional precepts and its radical subversion of those precepts.

What this new framework supports is a medium. That medium is light, and it has been employed by a whole range of artists in broad or narrow ways according to prediliction. Perhaps we might look to an artist like Frederick Sommer as the exemplary photographic artist, for he has not been afraid to travel freely over the total spectrum. Such daring has earned him condemnation, for he has not fitted easily into either of the old rival photographic camps. His oeuvre has ranged from 'straight', direct landscapes to fantastic collages, like *Artificial Leg*, to *clichés verres* such as *Smoke on Glass*. His influences have ranged from the direct stimulus of the subject before him to Leonardo da Vinci, mystical poetry, and Surrealism. In every case, he has used the medium, manipulated it or left it alone according to the subject matter.

This exhibition covers almost the full range of photographic expression. We are hopeful it will demonstrate the broad continuity of that expression, proving that the medium itself is richer, and that photographers' visions have been richer and broader than many have previously imagined.

4. Frederick Sommer: *Smoke on Glass*, 1965. (See catalogue entry no. 72.)

GERRY BADGER

→ LOOKING AT PHOTOGRAPHS

'The negative is the score: the making of the print the performance.'

ANSEL ADAMS

In most definitions of printmaking, the print is defined as an exactly reproducible image. In other words, the shared trait of the various media that constitute printmaking is that proof one of an image is identical to proof one hundred, or even proof one thousand. The only admissible deviation from this rule is a degree of wear and tear from the natural pressures of printing processes – deterioration of the plate and such like.

It is usually assumed that one process, photography, escapes this qualification. Not even the issue of wear and tear, it would seem, intrudes upon the perfect suitability of the photographic negative for infinite cloning. Merely project a fixed amount of light through this totally stable matrix on to an automatically sensitised sheet of paper, immerse in a couple of dishes of chemical solutions for a few minutes, then hang out to dry. There are no moving parts to cause wear by friction: the resultant prints ought to be identical.

However, theory is often different from practice. Although the machine automatically produces the negative, hand and eye have a greater say in the making of the print than is often imagined.

That photographic prints are entirely machine dictated is just one widely-held fallacy. The other misconception concerns the ubiquity of the photograph. It is blithely assumed that since in theory one can produce one hundred copies from a negative, photographers actually do it. However, the production of new negatives is a relatively simple matter, so photographers are almost frighteningly prolific in their production of fresh images – and eager to print their latest crop of pictures. Most, therefore, tend to make a few acceptable prints from a negative at any one time, before rushing

headlong to the next. They might return to especially successful negatives perhaps only on a few more occasions throughout their careers, making several more prints each time. The recent practice of producing limited, numbered editions of prints, following traditional print market procedure, has most probably increased rather than decreased the average numbers of prints of particular images.

This trend towards the limited edition print or portfolio certainly ought to produce a greater consistency of result. Photographers intending to publish portfolios are compelled to make larger batches of prints, using the same batch of paper, the same batches of chemicals, the same batch of toner. This is a far cry from their old, much more haphazard methods. Large editions demand that the variables be eliminated.

However, the cry for uniformity presents a problem in the minds of many photographers. If we take up Ansel Adams' musical analogy, we might ask ourselves if such uniformity is always so desirable. After all, a musical piece conducted and played the same way at each performance would quickly pall.

The answer surely, for both musician and photographer, must be left to individual taste and temperament. Some scores ask for the discipline and rigour of the consistent approach. Others will allow, even demand, the spontaneous, relaxed, abandoned approach. Some conductors are by nature fastidious, equable, reliable, consistent. Others are flamboyant, impulsive, tempermental, inconsistent. The musical world would be a dull one if it were not so.

And so would the world of photography if every photographer printed the same way, all exactly the same as each other, and with monotonous regularity year after year. Ansel Adams, musician and

photographer, is a well-known teacher of photographic techniques as well as being one of the medium's most renowned exponents. In musical terms he would be termed a classicist. He is methodical, correct, controlled. His knowledge of the practical application of photo-science is almost without parallel. His personal darkroom is equipped with every advanced technological aid. If one's life depended upon turning out a large number of perfectly matched prints one would turn to Ansel Adams. Yet he has always followed his own maxim – the negative is the score, the print the performance. His view of a negative over a period of time can be seen quite clearly to change in his print of *The Face of Half Dome*.

Adams is the author of one image that has come to symbolise the excitement felt over the recent upsurge of interest in the photographic print, *Moonrise, Hernandez, New Mexico*, a copy of which was sold for over $70,000.*

Now the question is not whether any photograph is worth such enormous sums of money, but whether those prepared to pay the price are aware that there are around 900 prints of the image in existence.

The dealer in photographic prints would claim that it is not strictly accurate to say that *Moonrise* exists in an edition of 900, for this implies that all versions of the image are more or less identical. On the other hand, one could not say, as some have claimed, that there are 900 different *Moonrises*, for Adams clearly has made some relatively large 'runs' of the print, especially recently. But he has been

* In a private sale in Colorado, a purported price of $71,000 was paid for a version printed to a size of 39¼ ×55½ inches. Adams first printed *Moonrise* in this size in 1974. There are twelve known to exist.

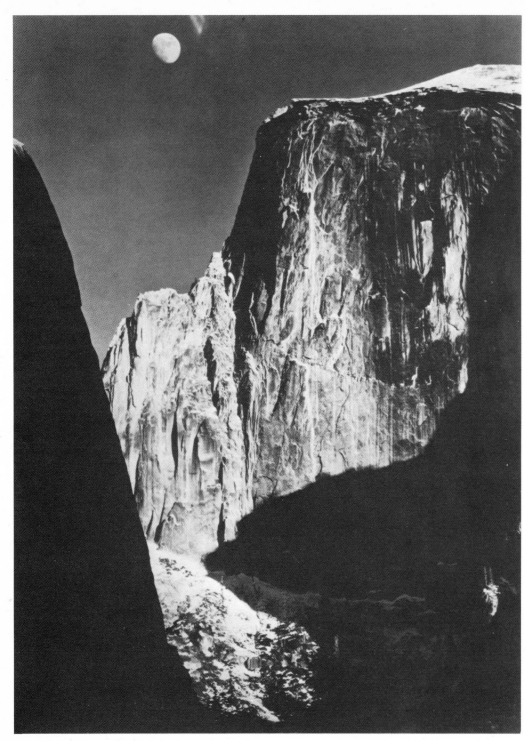

5. Ansel Adams: *Moon and Half Dome, Yosemite National Park*, 1960

The criteria become clear if one considers the extremes of camera choice, which we might categorise as 'small' and 'large' cameras.* The small camera is fast, lightweight, and mobile, perfectly suited for capturing that favoured, mythic subject of photographers – the spontaneous 'slice of life'. However, the small negative size means that enlarging to even a print size of 12×15 inches degrades the resolution of the image. 'Grain' becomes obtrusive and the whole image tends to fall apart. Of course, some make a virtue out of this 'fault', and, like Gary Hallman in *Chippewa Dam*, devote themselves to a deliberate exploitation of the particular hazy quality of grain and blur.

The large format camera produces images of maximum definition and tonality. Its drawbacks are that it is slow and cumbersome, used almost exclusively on a tripod. It could be said that small camera devotees tend towards a more mobile subject-matter – people on the wing, street action photography, news, war photography – while afficionados of the large camera opt for immobile subjects – landscape, architecture, still-life. However, this is a generalisation. Many photographers have been known to divorce that which is physically or psychologically convenient from that which is conceptually right, and professionals use both types of camera.

Our next important variable is choice of printing paper. In recent years, with a shrinkage in the market for black and white photography, the number of papers available to photographers has shrunk woefully. Quality too, has fallen, as manufacturers have steadily decreased the amount of silver in papers, further dulling the photographer's palette.

The basic differences between types of readily available papers lie in the tone of the image produced. The colour of the silver grains in a developed photographic paper is not simply neutral grey, but may be bluish, warm black, brown, greeny brown, even reddish. Colder tones, those tending to blue-black, are produced to emulsions composed of silver chloride crystals. Brown tones are produced by

* Cameras falling into the 'small', or 'miniature' category would be those models between the well-known 35 mm – taking a negative size of 36×24 mm – and '2¼ square' – taking a negative size of 6×6 cm, that is to say, 2¼ × 2¼ inches.
 'Large', or 'large-format' cameras are those models taking negatives from 5×4 inches to 10×8 inches in size. Some models even go up to a 24×20 inch negative size, though 10×8 inches is the largest readily available film size.

printing this negative since 1941, in any number of 'performances', and there are quite distinct variations in size, papers, and approach, plus the rather more unforeseen ravages of time. And this despite the fact that Adams is probably the most skilful and consistent printer in contemporary photography.

The variables, both within and without the photographer's control, are infinite, even for those concerned simply with realising that elusive 'straight' print from a 'normal' negative. The photographer/printmaker is faced with a long chain of choices which may vitally affect the outcome of the print at any one stage.

Much of this fine tuning is far from scientific in nature, but is improvisatory, executed at the last second by the intuition of the moment. Adams' analogy to music was well considered indeed. Many a print has been ruined by overdoing the fine tuning, often near the end of a complex sequence. The mistake might be small, but is irrevocable, as, for example, immersing a print for five seconds too long in the toner.

The most basic choices made by the photographer are choice of camera – or lack of it – and negative size. Technical limits set while shooting, therefore, already influence printmaking decisions.

emulsions in which silver chlorobromide crystals predominate. Type of developer, temperature of developer, the surface colour of the paper fibre itself, and chemical toning after the print has been otherwise processed, are further factors which affect image colour.

Choice of printing paper also has consequences, in concert with the negative itself, for the overall tonality of the print – the range and disposition of shades of grey or colour throughout the image. No paper or negative is capable of duplicating the the enormous range of luminosity encompassed by our eyes. The photographer must make a compromise, by using the materials of today, which cannot match the quality of those of yesteryear.

The search for the expanded tonal range seemingly lost by contemporary market papers has led some photographers to revive processes thought to be long redundant. Papers sensitised by hand, using either silver or platinum salts are again being used and another technique enjoying something of a revival is *printing-out-paper*, whereby the image self-develops upon the action of light. This was the standard printing method of the 19th century, and not only obviated the need for a darkroom, but permitted a greater range of tones than could be obtained with even the best of what are termed *developing-out-papers*.

Eastman Kodak retain a printing-out-paper on the American market, its qualities, not to mention its distinctive reddish-purplish tones attracting the attention of a number of today's photographers, as the examples by Linda Connor and John Goto will attest. Others, like Charles Hall, have gone even further and have begun to make albumen and salt prints. This resurrection of 19th-century processes is useful, not just in order to print new negatives, but to make high quality facsimile prints from old negatives, negatives which tend to defeat modern, less receptive papers.

With all these variables, one might now say potential controls, at his or her command, the choices for the creative photographic printmaker are wide indeed, particularly when one might also mix in techniques from the traditional arts and crafts, or from new technologies such as *xerography*. But the photographer's basic aesthetic problem, as long as he or she does not stray too far from the primary precepts of the medium, can be stated simply. It is, in effect, to dispose tonalities throughout the print. The word tonality is apt, for again the

musical analogy can be employed. The photographer's aim must be to achieve a harmony, a balanced distribution of tones within the print.

It is as important in photographic education to learn how to dispose print tonality as it is to dispose shapes within the picture frame. The two elements are of course interlinked, but as every printer finds out, the lens is somewhat capricious in the way it gathers light. That is the principal reason why the 'straight', one hundred per cent unmanipulated print is a relative rarity. Even in the hermetic, controlled environment of the studio, where the tonalities determined by the photographer's eye are put into effect through the control of lighting, exposure and development, the desired values are seldom translated exactly to the negative. Some adjustment is almost always necessary.

In the printing process, the photographer takes the matrix – the negative – and the medium – light – and utilises them in combination to make the print. By varying the amount of light penetrating each element of the negative on to the paper, the printer moulds the print's tonalities. Each negative is given an overall, base exposure, but by interposing a solid object between negative and paper over parts of the image during exposure – a technique known as 'dodging', or 'shading' – lighter tonalities are created. And then by giving more exposure to local parts – 'burning in' – darker tones are created. The medium – light – may be thought of as almost a sculptural tool. The photographer employs it to pull elements of the picture forward or push them back to create the desired illusions, perhaps a deep spatial effect, perhaps a flat image plane.

These manipulations can be made by a number of tools, but the preferred instrument tends to be the photographer's hands. The whole process of adding and subtracting light does tend to be intuitive, for results cannot be gauged until the print has been developed and fixed. The printer, literally, is working in the dark. Many are the frustrations when a photographer finally turns on the darkroom light and finds that one part of the image is too light, or another too dark. It is back into the darkroom, perhaps again, and again, and again. A photographer or printer might spend up to two or three days' hard, consistent work just to make one perfect print of an especially difficult negative. By that time his fine tuning controls have become very fine indeed, but he has no guarantee of

exactly repeating the process.

Few can appreciate the subtleties between one print and another, but at least a broad appreciation of the qualitative points should not be beyond the interested lay observer, given a reasonable degree of access to fine prints.

Considerations of quality bring us to the fundamental question of the lay observer, and the fundamental problem that bedevils the photographic art market. What is an 'original' photographic print?

The short answer is that any print made from the photographer's original negative is an 'original' print. Many would insist also that the print be made by the photographer, but such an insistence would be impracticable. Many photographers, including some of the medium's most famous names, like Cartier-Bresson and Kertesz, do not make their own prints. The majority of 19th-century prints would not be made by the photographer, a fact that makes them not a whit less sought after. What would seem more realistic, therefore, is that an original print be defined as emanating from the original negative, and carrying the photographer' approval as authentication – or the approval of the artist's estate if it is a posthumous reprinting of the negative.

Already, we are beginning to qualify our definition. And the anomalies become ever more complicated. What, for instance, do we make of the photographer who makes a copy negative – an inevitable degradation of print 'quality' – in order to protect the irreplaceable original negative? How do we view the products of the photographer who has his or her negatives printed not singly, by hand, but in large numbers, by one of the photo-mechanical processes, such as photogravure or collotype?

It is more difficult to draw a distinct boundary between a hand crafted process and the fully automated, mass reproduction methods. Many, for instance, find it difficult to accept *Camerawork** gravures as original prints, and likewise the fine *heliotype* or *collotype*

* *Camerawork* was a photographic quarterly published by Alfred Sieglitz between 1903 and 1917. As well as featuring the work of the photographic avant-garde, the publication was renowned for the quality of its design on fine rag and tissue paper, tipped in by hand. Copies of these gravures, including work by Stieglitz, Paul Strand, Edward Steichen, Alvin Langdon Coburn, can fetch up to $1,000 each, even more in one instance, a state of affairs that dismays those who see them merely as printed book illustrations, albeit high-class.

illustrations found in the superior 19th-century illustrated books.

We might solve these various dilemmas by returning always to first principles – firstly, what was the photographer's intention, and secondly, what is the result, regardless of photographer's intention. For example, if making copy negatives and then printing from them is a normal part of the photographer's practice, then prints made in this manner, degraded or not, must be accepted as authentic statements by that artist. If not part of the photographer's practice, then such prints must be viewed as unauthentic a misrepresentation of the artist's vision.

The precise details of the process, the function of the book or print, the size of the edition, and other considerations, may or may not elicit different conclusions as to its intrinsic merit. We may compare, for example, a *Camerawork* gravure and a *platinum* print of Paul Strand's *New York Street Portrait* of 1916. And can anyone deny that a print like Charles Negre's magnificent photogravure of Chartres Cathedral is anything other than one of the supreme achievements of photographic printmaking? It is surely a wholly authentic and masterly realisation of the original vision of its creator.

If one does treat each case according to its merits, then the whole question becomes not so much a case of 'how original', but 'how good?'. Again, putting the question in a different way and harking back to music, was Wagner necessarily the best conductor of his own music? He was not, if we are to believe informed contemporary opinion. And similarly, there are no doubt many photographers who have not realised all that they might from their negatives.

An artist's view of his own work also is likely to change over a career. Many photographers vary their printing approach quite widely over a couple of decades or so. Changes too, are forced upon the printer by changes in the types of materials available. We may see this in several examples, perhaps the most startling being that of Bill Brandt, who made a drastic change of mind regarding his printing around the mid-point of his long career.

As time often alters the artist's view, so the ravages of time work upon the physical fabric of the print itself. Dealers and scholars alike now tend to distinguish between what are termed 'vintage' prints – prints made 'around' the time of the negative – and 'non-vintage'

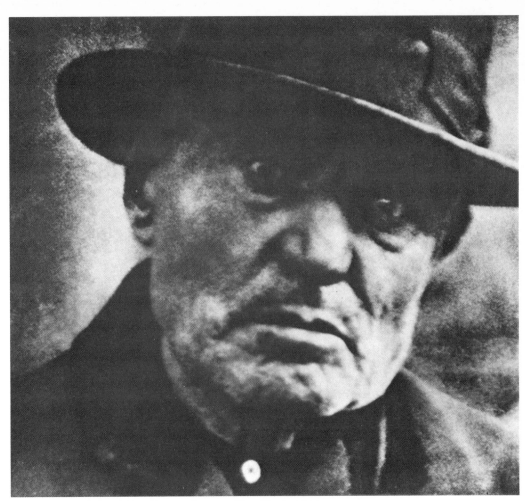

6. Paul Strand: *Man, Five Points Square, New York*, 1916

7. A. L. Coburn: *Self Portrait*, 1905

14

prints. Vintage prints tend to be worth
more in the marketplace, reflecting the
supposition that all photographers
printed better in the fresh, early days of
their careers.

The term 'vintage' at least provides a
framework of reference for those who
need it, and it does draw attention to the
fact that there are important differences
between prints and reinforce my point
that each individual case should be
treated on its own merits.

It is valuable to have an original,
contemporary 'vinatage' print from
Francis Frith's monumental large
Egyptian series of 1857. It is, I think, also
valuable to have a newly minted,
sparkling, superbly made facsimile print,
struck from the original glass-plate
negative and using substantially the
same 1857 process. The contemporary
Frith print in fine, unfaded condition is
obviously a great rarity, a prime
photographic treasure, intrinsically and
materially. The badly faded 'original', I
would suggest, is quite another matter.

This exhibition might be described as
an instant course in the connoisseurship
of the photographic print. Hopefully it
will demonstrate most of the primary
issues for the viewer, and illustrate the
perhaps surprising richness of the
photographic medium. The subject of
photographic printmaking is a complex
one, replete with subtle undercurrents. It
is a subject that deserves more study in
this country, by practitioner and lay
viewer alike. Good printers, after all, may
only become good, many only execute
commendable work if they can conceive of
it. The best way of conceiving what
constitutes a good print, and of learning
the more discriminating points of the
printmaker's craft, is by looking at fine
originals.

GERRY BADGER

→ CATALOGUE

2a

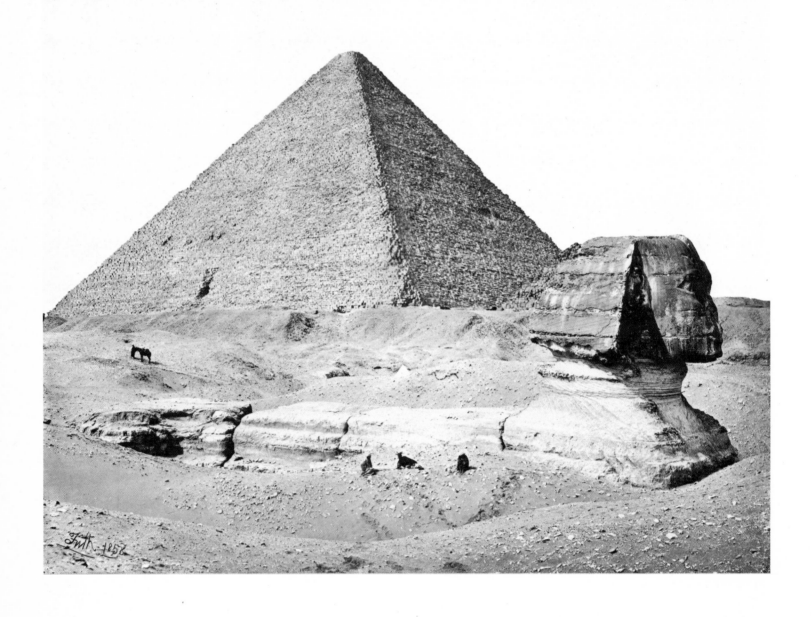

Frith. 1858

1830s–1870s
The first period of photography. The main feature of this period was the supplanting of the daguerreotype, the first commercial photographic process, by negative/positive processes, firstly based on paper, then on glass. Whatever the process, photography was a slow and inconvenient medium during this period. Negatives were printed by contact only. Photolithography was the primary photo-mechanical process of the era, though the groundwork was laid for many of the later developments.

All dimensions are in millimetres, height before width. Dimensions not shown were unavailable at time of printing.

1. David Octavius Hill (1802 – 1870) and
Robert Adamson (1821 – 1848)
The Rev. Mr Thomas Henshaw Jones, 1845
carbon print c.1900 made by Alvin Langdon Coburn from the original calotype
205×156
Gerry Badger

2a. Francis Frith
Pyramid with Sphinx
albumen print made by Chicago Albumen Works (1979) from original glass-plate negative
398×493
Janet Lehr Inc, New York

2b. Francis Frith
View from Biggeh, 1857
albumen
159×223
Gerry Badger

2c. Francis Frith
Mosque of Kait Bey, 1858
albumen from glass/collodian negative
355×470
Daniel Wolf Inc, New York

3. Unknown
Portrait, 1850s
salt print
140×115
Light and Line, Peter and Pauline Agius

4. Poitevin
Barnyard, 1850s
photolithograph
269×367
Sam Wagstaff, New York

5. Richard Beard
Portrait, c.1841
hand-tinted daguerrotype
John Benton-Harris

6. Fitzeau
Paris, 1850s
engraved daguerreotype
51×73
Sam Wagstaff, New York

7. Roger Fenton (1819 – 1869)
Head from the Tomb of Mausolius, 1850s
salt print
272×227
Royal Photographic Society

8. Charles Nègre (1820 – 1880)
Chartres Cathedral, 1850s
photogravure
722×479
Alain Paviot, Galerie Octant 19, Paris

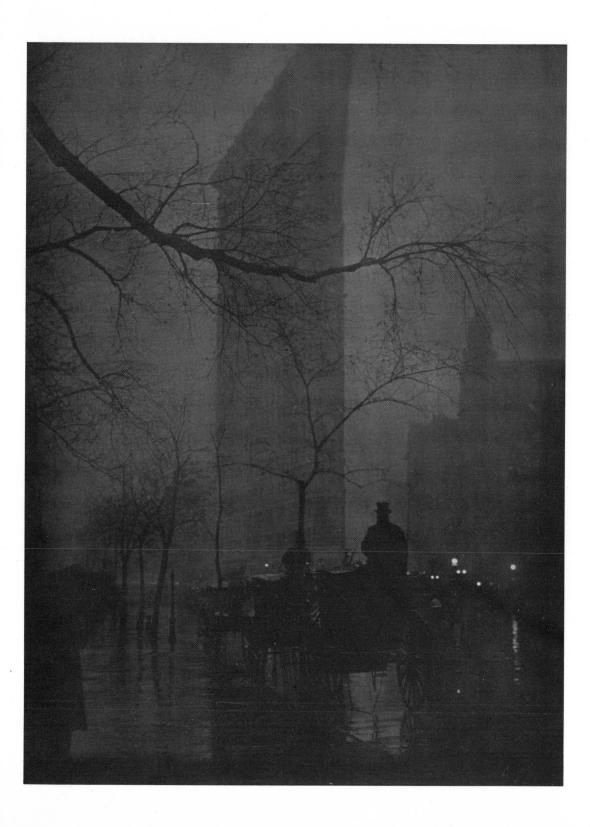

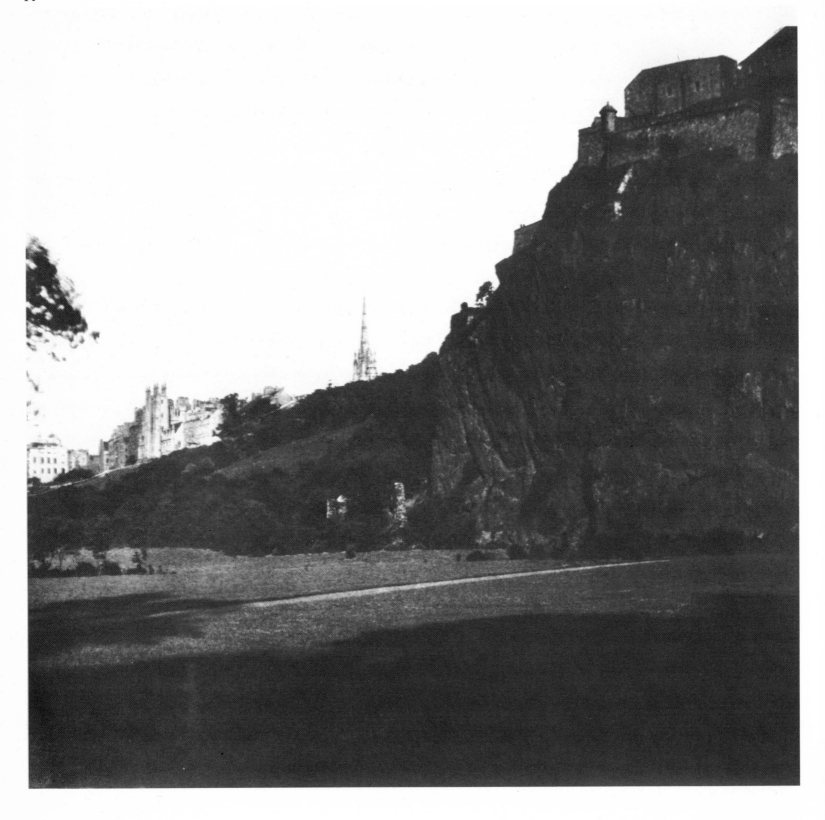

*Robert MacPherson
Falls of Tierni, 1850s
albumen
Gerry Badger

9. Dr John Murray
Pavilion and Mosque attached to the Taj Mahal, India, 1855 or 1856
salt print
330×450
Collection of J. Somerset Murray
on loan to Victoria & Albert Museum

10. Dr Thomas Keith
Greyfriars Churchyard, c.1853 – 55
printing out paper, gold toned. Modern print made from original waxed paper negative 1981
270×244
Edinburgh Public Libraries

11. Dr Thomas Keith (1827 – 1895)
High School Wynd, c.1853 – 55
salt print from waxed paper negative
281×255
Edinburgh Public Libraries

12. Lineus Tripe
Isle on the south side of the Pudhu Mandacam, 1857 albumen from waxed paper negative
358×296
Royal Photographic Society

13. Le Secq
Landscape, c.1857
photolithograph
220×321
Sam Wagstaff, New York

14. Dr Thomas Keith
Edinburgh Castle from Princes Street Gardens, c.1853 – 55
platinum print, made c.1900 from original waxed paper negative
281×255
Edinburgh Public Libraries

15. Dr Thomas Keith
Edinburgh, c.1853 – 55
silver print, made from original waxed-paper negative combination photograph, multiple exposure
179×214
Edinburgh Public Libraries

*P. G. Fitzgerald
Palace of the Rajah of Nagode, c.1855
waxed paper negative
170×218
private collection

16. Jackson Brothers, Oldham
Family Portrait, 1860s
ambrotype, hand tinted
diameter 90
Michael Regan

6

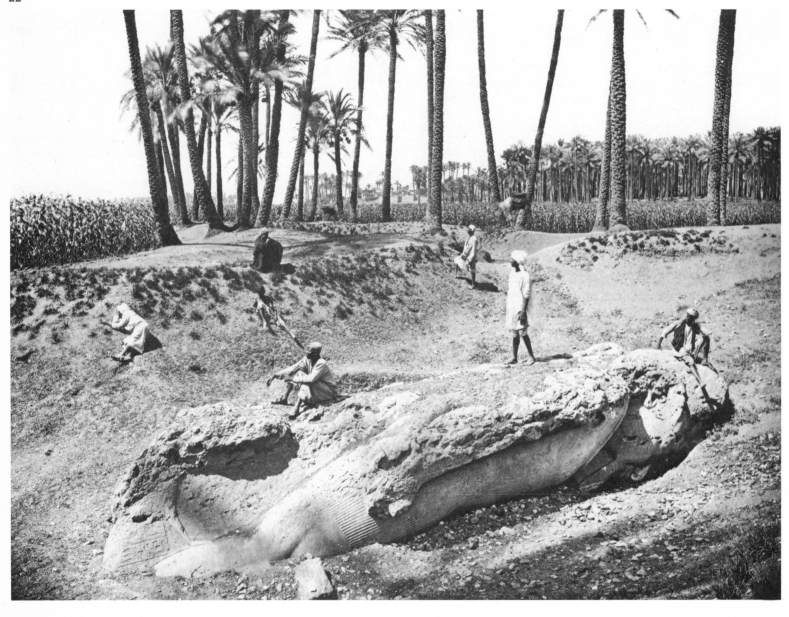

1870s–1900
The introduction of the dry plate and roll film was an irreversible trend towards making photography quick, convenient, and more automated. In a more traditional vein, the platinotype, perhaps the most beautiful of all photographic processes, was introduced. Great strides were made in photo-mechanical processes. The Woodburytype, the collotype, the photo-gravure, and, most important of all, half-tone reproduction, were developed during this period.

17. Henry Peach Robinson (1830 – 1901)
Autumn, 1864
albumen
365×582
Royal Photographic Society

18. Giroux
Waterfall, 1865
saltprint, combination image
353×268
Sam Wagstaff, New York

19. Francis Bedford (1816 – 1894)
Watersmeet, The Rustic Bridge and Falls, c.1865 – 70
albumen
145×209
Gerry Badger

20. Francis Bedford
Bolton, Posforth Beck, c.1865 – 70
albumen
145×209
Gerry Badger

21. Carleton Watkins (1829 – 1916)
Yosemite Valley, c.1866
duotone poster
584×736
(Daniel Wolf Inc, New York, 1978)
© Daniel Wolf Inc
Gerry Badger

*John Thomson
from *Street Life in London*, 1877
woodburytype
119×92
Guildhall Library, City of London

*John Thompson
Chinese Portrait, c.1870
albumen, hand coloured
Janet Lehr Inc, New York

*John Thompson
Chinese Portrait, 1870
albumen, hand coloured
Janet Lehr Inc, New York

22. Bechard-Quinsac
Statue of Sesostris, c.1865
phototype
267×379
Sam Wagstaff, New York

23. Thomas Annan
193 High Street 1868, from 'Old Streets and Closes of Glasgow' series
carbon print
278×224
Mitchell Library, Glasgow

24. Thomas Annan
193 High Street 1868, from 'Old Streets and Closes of Glasgow' series
photogravure
216×178
Gerry Badger

23

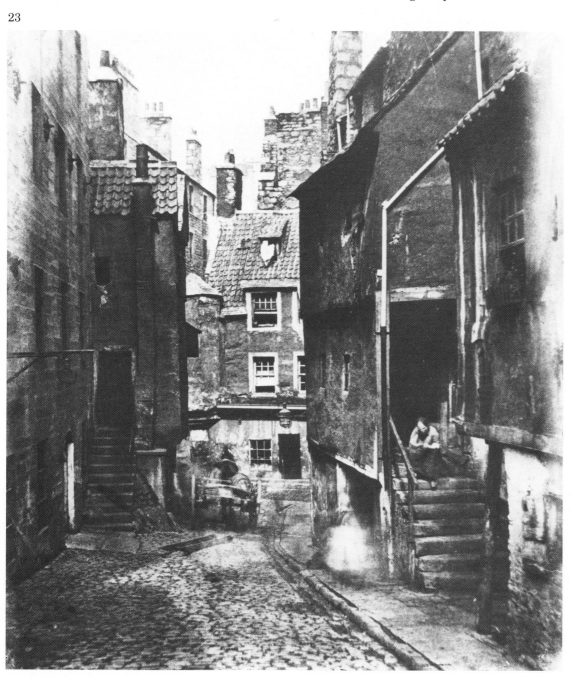

1900s–1930s
The trend towards miniaturisation
and ease of use continued. Also the
introduction of modern silver
papers and the gradual phasing
out of the platinotype led towards
a much greater standardisation of
photographic techniques. The
development of the first really
practical colour process, the
autochrome, made photography in
colour, though a rarity, a viable
option for photographers.

34

*Max Koch and Otto Rieth
from *Der Akt*, 1890s
collotype
195×160
Gerry Badger

25. Marey
Etudes de Physiologie Artistique,
1893
phototype, plate II
152×124
Sam Wagstaff, New York

26. Frederick Evans (1853 – 1943)
Lincoln Cathedral
platinum print
195×122
Royal Photographic Society

27. Peter Henry Emerson
(1856 – 1936)
Towing the Reed
platinotype from 'Life and
Landscape on the Norfolk Broads'
1886
217×266
Royal Photographic Society

*Charles F. Lummis
Isleta Pottery, 1890
cyanotype
107×174
Susan Mann

28. Jughaendel
Egyptian gravure, c.1898
284×364
Sam Wagstaff, New York

*Robert Demachy (1859-1937)
Nude Study
gum bichromate
364×224 (oval)
Royal Photographic Society

29. Alfred Stieglitz (1864 – 1946)
Winter, New York, 1898
photogravure
306×262
Royal Photographic Society

30a. Alvin Langdon Coburn
(1882 – 1966)
Tree in Greyfriars Cemetery, 1905
photogravure
191×158
George Eastman House,
Rochester, New York

30b. Alvin Langdon Coburn
(1882-1966)
Trafalgar Square, c.1905
platinum and ferroprussiate
281×221
Janet Lehr Inc, New York

31. J. C. Annan
Stirling Castle, 1906
gravure
195×283
Royal Photographic Society

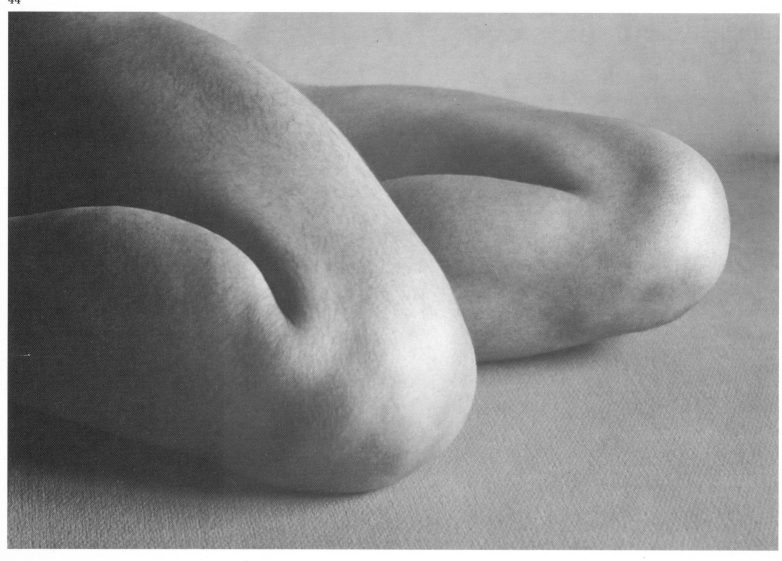

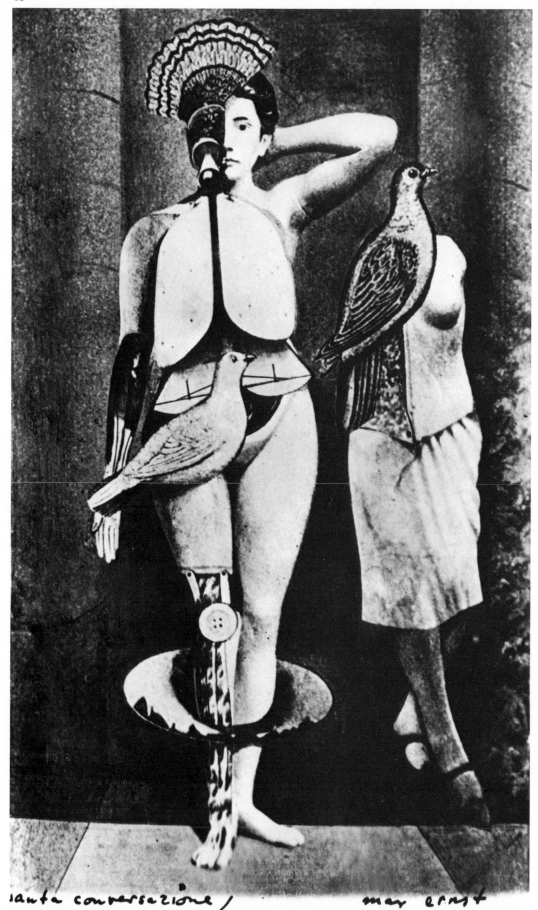

43

santa conversazione / *max ernst*

32. Edward Steichen (1879 – 1973)
Flatiron Building
'Camerawork' halftone, 1906
214×165
Royal Photographic Society

33. E. J. Bellocq (1873 – 1949)
Storyville Prostitute, New Orleans,
c.1912
printing out paper, gold toned
print made by Lee Friedlander
from original glass plate
250×202
Gerry Badger

34. Frantisek Drtikol (1878 – 1961)
Nude, 1914
photogravure
300×210
Collection of the Art Museum,
University of New Mexico,
Albuquerque

35. Paul Strand
New York Portrait, 1915
contact print on Eastman
platinum paper
310×236
Museum of Modern Art, New York

36. Paul Strand (1890 – 1976)
New York, 1915
photogravure from 'Camerawork'
1917
215×162
Jonathan Bayer

37. Christian Schad
Schadograph 1918
printing out paper, gold toned
64×90
Museum of Modern Art, New York

38. Christian Schad
Amourette, c.1918
photogram
64×90
Museum of Modern Art, New York

39. Ansel Adams (b.1902)
Moonrise, Hernandez, Mexico
silverchloride/bromide
393×494
Royal Photographic Society

40a. Ansel Adams
*Monolith, the face of Half Dome,
Yosemite National Park*, 1927
silver chloride parmelian print
private collection

40b. Ansel Adams
*Monolith, the face of Half Dome,
Yosemite National Park*, 1927
modern print, enlarged and gold
toned
private collection

41. Hugo Erfurth
Frau Zwintscher, 1920s
bromoil
272×190
Gernsheim Collection, Humanities
Research Center, University of
Texas at Austin

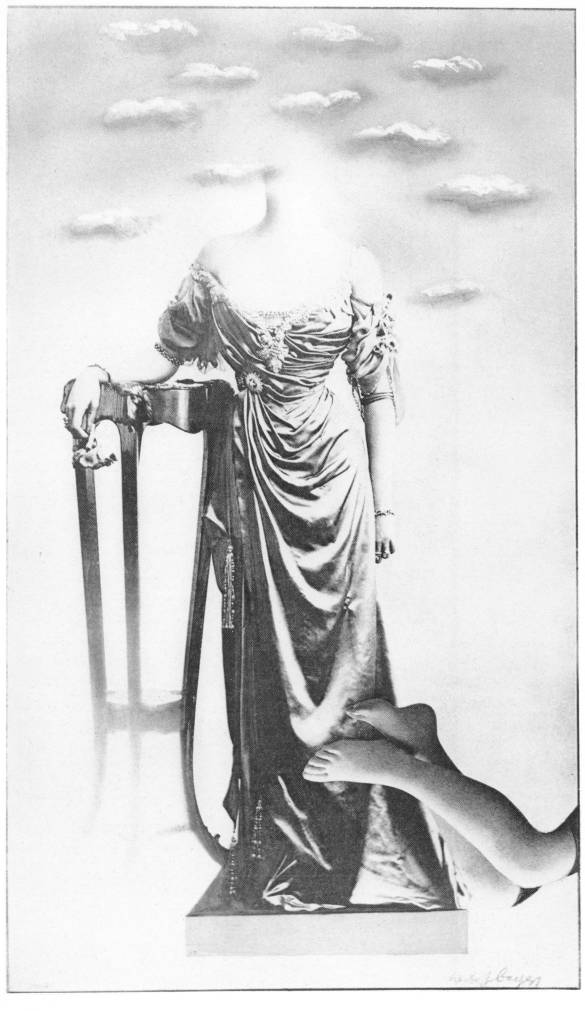

42. Francis Bruguière (1879 – 1945)
Cut Paper Abstraction, 1925
silver print
186×240
Victoria & Albert Museum

43. Max Ernst (1891 – 1976)
Santa Conversazione, 1925
photomontage, modern print
230×140
Arts Council Collection

44. Edward Weston
Knees (H-515), 1927
platinum print
157×233
University of Nebraska Art
Galleries, Lincoln, Nebraska

45. Laszlo Moholy-Nagy
Mein Name ist Hase, 1927
silver print (re-issued print 1973)
392×370
Victoria & Albert Museum

46. Ruth Casson
Accident, 1930s
gelatin silver print
294×243
Gernsheim Collection, Humanities
Research Center, University of
Texas at Austin

*Joseph Sudek 1896-1976
Lost Roses
silver print
280×229
Sheldon Memorial Art Gallery,
University of Nebraska-Lincoln

47. Herbert Bayer
Lonely Metropolitan, 1932
photomontage (re-issued 1968)
382×226
Victoria & Albert Museum

48. Walker Evans
*Main Street, Saratoga Springs,
New York*, 1933
silver print
186×146
Joseph E. Seagram & Sons Inc,
New York

49. Walker Evans (1903 – 1975)
Main Street, Saratoga Springs,
1933
silver print, printed by Andos
Chan
Walker Evans Estate

50. Henri Cartier-Bresson
(b.1908)
Seville, 1933
silver bromide print
198×296
John Benton-Harris

1930s–Present
The three most important developments during this period are the introduction of the 35mm camera, the development of Kodachrome and other colour emulsions and the invention of instant photography. The trend towards standardisation has increased but there are signs of a reversal in this trend by a small but influential minority who have revived many of the historical techniques in an effort to utilise the full range of expression open to photographers.

51. Henri Cartier-Bresson (b.1908)
Seville, 1933
photogravure plate from 'Photographs' by Henri Cartier-Bresson (Jonathan Cape, London 1964) © Henri Cartier-Bresson
Gerry Badger

52. Brassai (b.1899)
Femme-Amphore, c.1935
silver print, cliché verre
238×178
International Museum of Photography, George Eastman House, Rochester, New York

53. Paul Outerbridge Jr (1896 – 1958)
Portrait
tri-chrome carbro
G. Ray Hawkins Gallery, Los Angeles

54. Bill Brandt (b.1904)
Isle of Skye, 1947
vintage silver print
230×196
Victoria and Albert Museum

55. Hans Bellmer
Still Life, 1940s
silver print
Kasmin/Knoedler

56. Hans Bellmer
Doll, 1940s
silver print with some hand-tinting
280×280
Stefan Lennert

57. Gyorgy Kepes (b.1906)
Hydrogliphic Body, 1942
silver print
228×178
International Museum of Photography, George Eastman House, Rochester, New York

58. Aaron Siskind (b.1903)
Gloucester IH, 1944
silver chlorobromide print
321×251
Gerry Badger

59. Irving Penn (b.1917)
Cuzco Children, 1948
platinum print mounted on aluminium
Robert Forbes

60. Edmund Teske
Portrait of Kenneth Anger No. 1, 1948
toned stained, solarized print
Art Institute of Chicago

61. Edmund Teske
Portrait of Kenneth Anger No. 2, 1948
negative print
Art Institute of Chicago

52

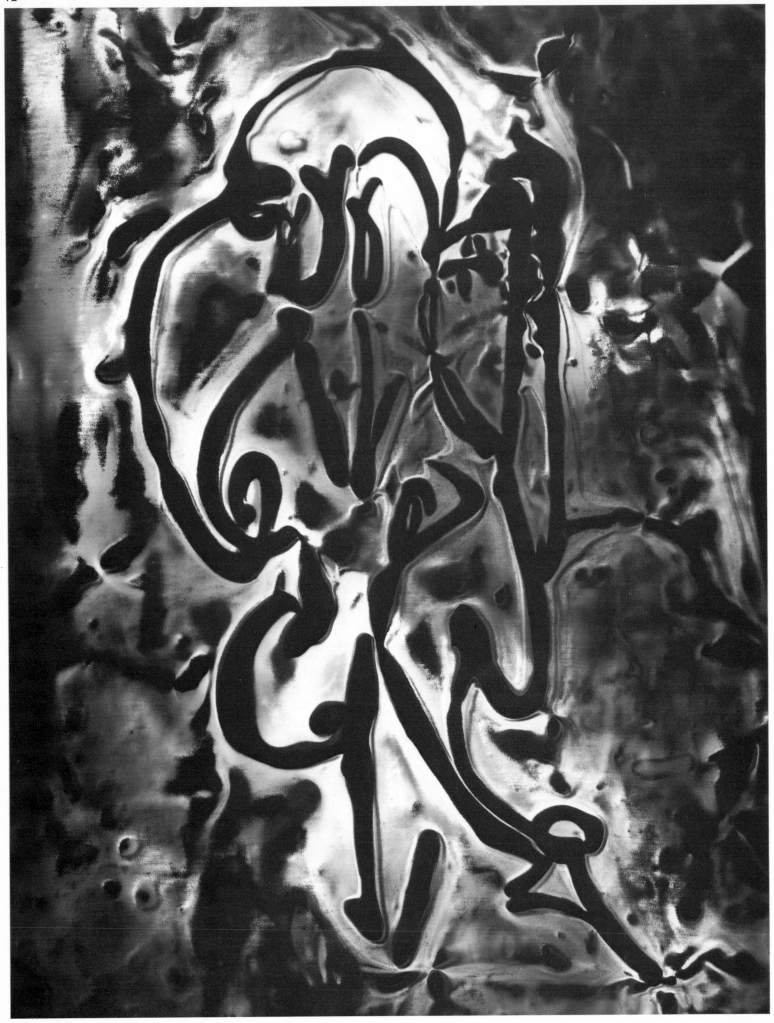

57

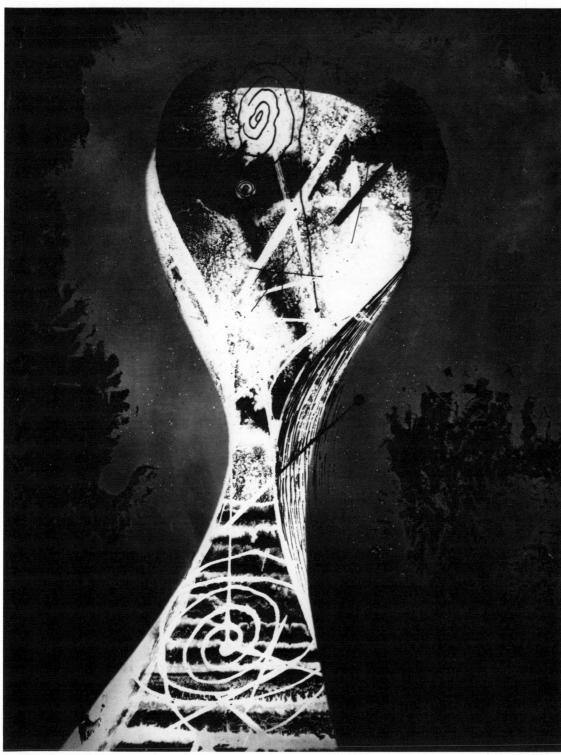

62. Irving Penn
Nude No. 1, c.1949
silverprint, bleached and toned
406×366
Museum of Modern Art, New York

63. Otto Steinart
Negative Nude, 1950
gelatin silver print
395×303
Gernsheim Collection, Humanities
Research Center, University of
Texas at Austin

64. Edward Steichen
Night on 40th Street, New York,
1925
printed c.1950
gelatin silver print
406×344
Joseph E. Seagram & Sons Inc,
New York

65. Frederick Sommer
The Thief Greater than his loot,
1955
silver print
205×127
Museum of Modern Art, New York

66. Eduardo Paolozzi
Lepsius Canon
From 'The History of Nothing',
1960
collage
Freda Paolozzi

67. Nigel Henderson (b.1917)
Head of Man, 1956 – 61
oil and photographic process on
card
1524×1219
Arts Council Collection

68. Pierre Cordier
Homage à Man Ray 1, 1960s
chimigramme
295×372
Gernsheim Collection, Humanities
Research Centre, University of
Texas at Austin

69. Cole Weston
Palo Corona Rand, California,
1962
colour type C. dye transfer print
288×360
Victoria & Albert Museum

70. Marie Cosindas
Boston, 1963
gelatin silver print
206×179
International Museum of
Photography, George Eastman
House, Rochester, New York

71. Aaron Siskind
Rome: Arch of Constantine 10,
1963
silver bromide print
332×243
Gerry Badger

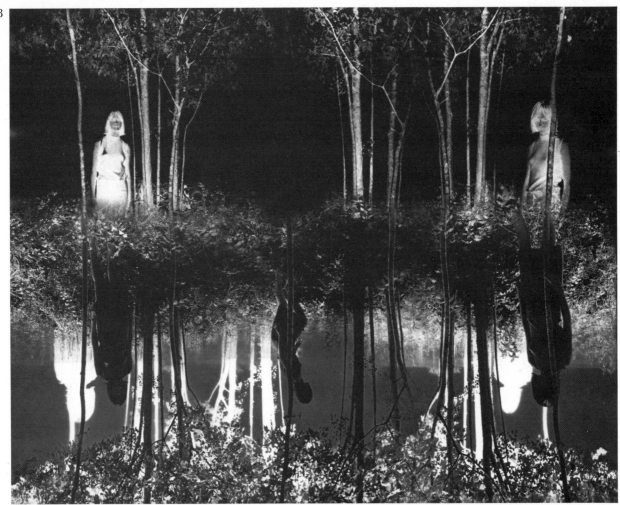

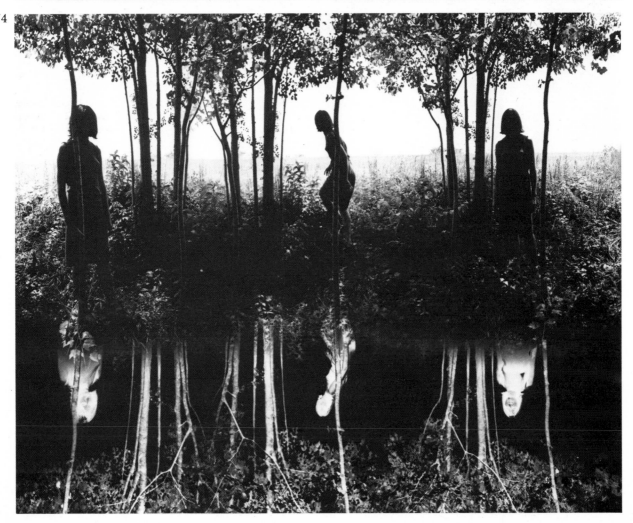

102

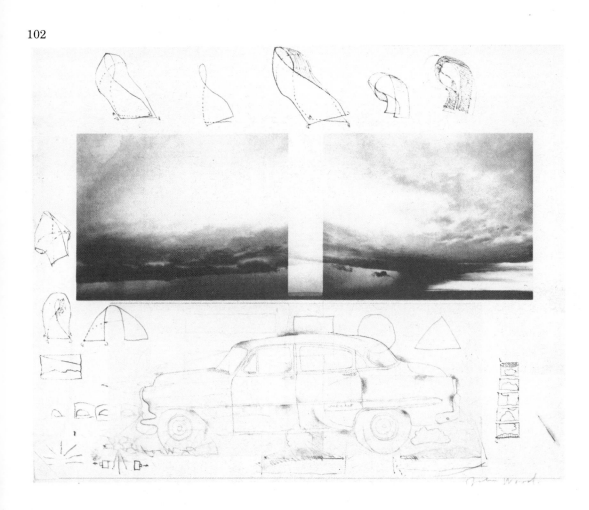

72. Frederick Sommer
Smoke on Glass (N-403), 1965
silver print
340×267
Nebraska Art Association

73. Jerry Uelsmann (b.1934)
Small woods where I met myself,
1967
gelatin silver print
274×346
International Museum of
Photography, George Eastman
House, Rochester, New York

74. Jerry Uelsmann
Small woods where I met myself,
1967
gelatin silver print
274×346
International Museum of
Photography, George Eastman
House, Rochester, New York

75. Jerry Uelsmann
Small woods where I met myself,
1967
gelatin silver print
260×321
International Museum of
Photography, George Eastman
House, Rochester, New York

76. Jerry Uelsmann
Small woods where I met myself,
1967
silver print, combination
photograph
190×346
International Museum of
Photography, George Eastman
House, Rochester, New York

77. Jerry Uelsmann
Untitled, 1969
silver print, combination
photograph
248×313
Victoria & Albert Museum

78. Gary Metz
Song of the Shirt, 1967
offset lithograph
115×165
Museum of Modern Art, New York

79. Alice Wells (b.1929)
Untitled, 1967
silver print, solarised and
chemical stained
279×356
Visual Studies Workshop,
Rochester, New York

80. Naomi Savage (b.1927)
Lower Torso, c.1968
inkless intaglio
405×330
Museum of Modern Art, New York

111

124

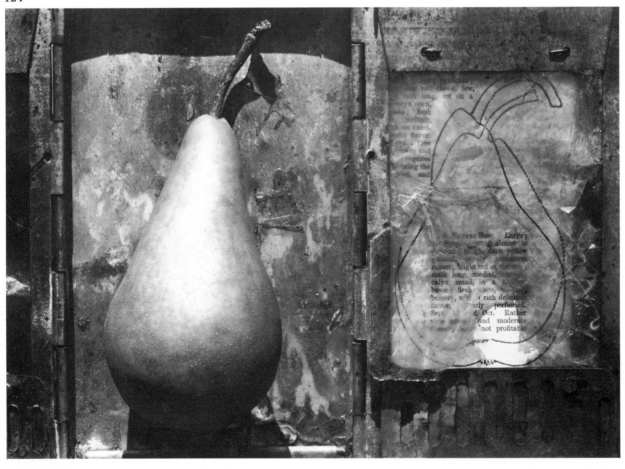

132

91. Wynn Bullock (1902 – 1975)
Wood, 1971
gelatin silver print
181×241
Center for Creative Photography,
University of Arizona

92. Wynn Bullock (1902 – 1975)
Fallen Tree Trunk, 1972
gelatin silver print
242×191
Center for Creative Photography,
University of Arizona

93. Linda Connor (b.1944)
Untitled, 1973
gold toned printing out paper
252×203
Victoria & Albert Museum

94. Karen Truax (b.1946)
Somnolent Staircase, 1973
silver print, hand coloured
G. Ray Hawkins Gallery, Los
Angeles

95. Keith Smith (b.1938)
Untitled, 1973
collage/photo etching
359×280
Visual Studies Workshop,
Rochester, New York

96. Keith Smith (b.1938)
Fantasy Friend, 1974
photo etching
330×260
Visual Studies Workshop,
Rochester, New York

97. John Blakemore (b.1936)
Tree Stump, Derbyshire, 1974
chlorobromide
184×154
Gerry Badger

98. John Blakemore
Tree Stump, Derbyshire, 1974
duotone plate from John
Blakemore: 'British Image 3' (Arts
Council of Great Britain, London,
1977) © John Blakemore

99. Thomas Joshua Cooper
(b.1947)
*Ceremonial Stillness, near
Matlock, Bath*, 1974
silver chlorobromide, contact print
120×169
Gerry Badger

100. Thomas Joshua Cooper
(b.1947)
*Ceremonial Stillness, near
Matlock, Bath*, 1974
silver chlorobromide, enlargement
118×168
Arts Council Collection

101. James Hajicek (b.1947)
Albuq/Belen, 1974
cyanotype
222×162
Collection of the Art Museum,
University of New Mexico,
Albuquerque

102. John Wood (b.1922)
*Untitled (Landscape with drawn
cars)*, 1974
collotype
305×359
Visual Studies Workshop,
Rochester, New York

103. John Wood
Untitled, 1974
collage/xerox/drawing
260×305
Visual Studies Workshop,
Rochester, New York

104. Joan Lyons (b.1937)
Self Portrait, 1974
photo lithograph
660×482
Visual Studies Workshop,
Rochester, New York

105. Joan Lyons (b.1937)
Prom Dress, 1975
six offset photo lithographs
1753×864 overall
Visual Studies Workshop,
Rochester, New York

106. John Benton-Harris (b.1939)
Buckingham Palace Stables, 1975
silver bromide, printed on
condenser enlarger
287×190
John Benton-Harris

107. John Benton-Harris
Buckingham Palace Stables, 1975
silver bromide, printed on cold
cathode enlarger
287×190
John Benton-Harris

108. Lynda Connor (b.1944)
Untitled (pyramid with camel),
1975
printing out paper, gold toned
200×255
Collection of the Art Museum,
University of New Mexico,
Albuquerque

109. Len Gittleman
Untitled, 1975
monoprint (silkscreen over
photographic half-tone)
91×285
Museum of Modern Art, New York

110. John Pfahl
*Pink Rock Rectangle, Artpark,
Lewiston, New York*, 1975
type C print
354×203
Visual Studies Workshop,
Rochester, New York

111. Daryl Curran
Untitled
vandyke print
375×560
Royal Photographic Society

112. Daryl Curran
Reunion, 2nd state, 1976
cyanotype
560×375
Royal Photographic Society

113. Richard Hamilton (b.1922)
Palindrome, 1976
collotype
595×440
Sheffield City Art Galleries

114. Van Deren Coke (b.1921)
Recollections: EVD, 1976
collotype
402×306
Collection of the Art Museum,
University of New Mexico,
Albuquerque

115. Richard Misrach (b.1949)
Boojum III, 1976
silver chlorobromide, selenium
toned
375×375
Ricardo Gomez Perez

116. Joan Myers
Cactus Actor, 1976
hand-coloured toned gelatine
silver print from a paper negative
399×496
Center for Creative Photography,
University of Arizona

117. Joyce Neimanas (b.1944)
Movie Still, 1976
silver print with ink and
flexichrome colour
406×505
Art Institute of Chicago

118. Robert Fichter (b.1939)
Machine in the Garden, 1976
silver print montage and drawing
409×507
Art Institute of Chicago

119. Richard Pare
Dallas, 1976
Polaroid SX70
78×78
Richard Pare

120. Richard Pare
Dallas, 1976
printed by Acme Printing
Company from a Polaroid SX70
original © Richard Pare
Richard Pare

121. Paul Joyce (b.1941)
*Abandoned buildings, Drainage
ditch, Eglwysfach* 1977/8
platinum, print made by Martin
Axon, 1981
465×220
Paul Joyce

122. Paul Joyce
*Abandoned buildings, Drainage
ditch, Eglwysfach*, 1977/8
silver print
469×209
Paul Joyce

Page 1 Wanda Hammerbeck 3 March 1978
Oakland, California

3 March Decision made to deposit a photographic fossil print
of a hiking boot track (see Replica # 76-2a) near a popular
hiking trail at Alameda Memorial State Beach in Alameda
County, California.

Around 1:00 p.m. arrived at the regional park beach,
parked and walked westward to the shoreline (approximately
30 meters). After a short search in a southerly direction
the trail was located and several fresh hiking boot tracks
were discovered in the damp sand. A hole was dug in the
sand in the exact location of one of these tracks and the
piece of stone with the printed image of a similar hiking
boot track was placed in the depression (refer to # 76-2a).

The piece of flagstone measured 29.2 cm. by 27.9 cm.

One photograph made of general vicinity facing north.
One close-up photograph of the pseudo-fossilized track made
facing east. (See photographs below)

An additional replica of this hiking boot fossil (refer
to Replica # 76-2b) was made and given to Dave Reed of
Miami, Florida for further study.

Description of Photograph *hiking boot*	Photograph No. *76-2a*
Deposited By *Doug Muir*	Date Deposited *3 March 1978*
Field Notes *yes, N.A.*	
Depositional Environment *Alameda, California* (Locality and Loc. No.)	
Collector _____	Date Collected _____
Address _____	Correspondence _____
Photo Coverage *up, general, ground level* Aerial (Flight No.) and/or Ground Level	

DATE	REVISED	DOCUMENT NO
3 Mar. 1978		*76-1*

SCALE *2cm = 2.3cm*

123. Gail Skoff (b.1949)
Trance Dancer, 1977
silver print, hand coloured
304×304
Center for Creative Photography,
University of Arizona

124. Olivier Parker (b.1941)
Bosc, No. 11, 1977
silver chlorobromide, contact
print, selenium toned
127×178
Ricardo Gomez Perez

125. Robert Golden
Nazi Poison, 1977
artwork and photograph for
Socialist Workers Party poster
594×418
Robert Golden

126. Wanda Hammerbeck
print from 'Depositions', 1978
bromide combination print
711×559
Visual Studies Workshop,
Rochester, New York

127. Kathryn Schooley-Robins
At Jim's, October, 1978
cyanotype, hand-coloured
54×533
Center for Creative Photography,
University of Arizona

128. Jan Groover (b.1943)
Untitled No. 8870, 1978
type C. print
509×406
Waddington Galleries

129. Bill Brandt (b.1904)
Isle of Skye
modern silver print
Paul Joyce

130. Susan Rankaitis
Untitled, 1979
gelatin silver print, toned and
chemically altered
278×344
Center for Creative Photography,
University of Arizona

131. Charles Hall (b.1939)
Eldertree and Ivy, 1979
albumen
255×204
Charles Hall

132. Manuel Alvarez Bravo
(b.1902)
Ixtaccihuatl, c.1979
platinum contact print
40×55
Ricardo Gomez Perez

133. Marc Chaimowicz
Three Intervals, 1979
photographs, hand tinted with
wood construction
2 panels, each 639×321
Arts Council Collection

134. Carol Drobek
Untitled, from the Spring series,
1979
colour photogram
508×407
Visual Studies Workshop,
Rochester, New York

135. Bea Nettles (b.1946)
proof sheet from 'Flamingo in the
Dark', 1979
889×584
© Bea Nettles 1979

136. Charles Hall (b.1939)
Washing Line, 1979
salt print
204×255
Charles Hall

137. Joel-Peter Witkin
*Mother (with Retractor,
Screaming) and Child*, 1979
gelatin silver print, bleached and
chemically stained
355×360
Sam Wagstaff, New York

138. Joel-Peter Witkin
Expulsion from Paradise, 1979/80
gelatin silver print, bleached and
chemically stained
380×380
A. Robert Samuel Gallery Ltd,
New York

139. Doug Prince (b.1943)
Kitchen Window, 1980
plexiglas photosculpture (3
separate images printed on
individual sheets of graphic arts
film arranged at different levels
inside a plexiglas box)
134×134×64
Witkin Gallery, New York

140. Jeff Gates (b.1949)
Breastplates no. 9, 6/50, 1980 print
silver, solarised
490×485
G. Ray Hawkins Gallery, Los
Angeles

141. Joan Fontcuberta
La Urna Te Olvida, Amnistia,
1980
silver print, combination
photograph sepia toned
267×267
Ricardo Gomez Perez

142. Duane Michaels (b.1932)
*Untitled with text (figures in
interior)*, 1980
silver print
Travelling Light Photography Ltd

143. Peter de Lory
Untitled (landscape), 1980
silver print, hand coloured
Peter de Lory

144. Christopher James
Metropolitan Museum, 1980
silver print, hand tinted and
enamelled
152×230
Witkin Gallery, New York

145. Peter Kennard
The Haywain with Cruise Missiles,
1980
silver print photomontage
Peter Kennard

146. Sheila Metzner (b.1939)
Michal, 1980
tri-chrome carbro, fresson colour
photograph
Daniel Wolf Inc, New York

147. Jean Marc Prouver
The Wrestlers, 1980
silver bromide, hand colouring and
letraset
370×241
David Dawson Gallery

148. John Goto
Photogram Still Life, 1980
printing out paper, gold toned
305×408
John Goto

149. Chuck Close
Stanley, 1980
large format polaroid print
2032×1016
The Pace Gallery, New York

150. Bea Nettles (b.1946)
Blue House, 1980
kwik print on vinyl
406×508
© Bea Nettles 1980

151. Tim Mara (b.1948)
Self Portrait with Family, 1981
bromide, combining continuous
tone with photo-mechanical
half-tone
914×914 overall
Tim Mara

152. Eileen Cowin
Cactus Garden
quick proof
508×610
G. Ray Hawkins Gallery, Los
Angeles

153. Suda House
What's A Woman To Do?
silkscreen, xerox on fabric
Suda House

→ PHOTOGRAPHIC PROCESSES

The following is a brief glossary of the processes to be seen in this exhibiton. For a fuller account of most of these techniques, probably the best source is Valerie Lloyd's extensive text in Bruce Barnard's book *Photo-Discovery* (Thames and Hudson/*Sunday Times*). The period of most general use for each process is indicated, though each has enjoyed some kind of revival in the recent photographic boom.

Daguerreotype (1830s – 1860s)
The daguerreotype was invented by Louis Jacques Daguerre, and announced to the world on 7th January 1839. The first commercially successful photographic process, the daguerreotype was a unique, direct-positive image produced on a silver halide coated copper plate, without the intermediary stage of a negative. After exposure of the plate, the image was developed by fumes of mercury. Daguerreotypes were sometimes hand-tinted, and usually mounted in cases with cover glass to protect the delicate surface image.

Calotype (1841 –1860s)
The first practical negative-positive process, the calotype was William Henry Fox-Talbot's improvement on *photogenic drawings*, his direct printing process. Patented in 1841, the calotype employs paper as the base for negatives and for subsequent positive prints. Writing paper is coated with solutions of silver salts, is exposed and then developed, thereby producing a negative. In order to produce a positive the negative is placed directly against another, similarly sensitised sheet of paper and exposed in sunlight. The resultant print is known as a *salt print* or *salted paper print*. Salt prints from paper negatives are characterised by a roughish texture caused by the paper fibres of the negative, incorporated in the image.

Waxed Paper Negative (1850s)
An improvement on the calotype introduced by Gustave Le Gray in 1850, and used until gradually supplanted by the collodion wet plate. The paper was waxed before exposure and after development to heighten its translucency and thereby increase print detail.

Cyanotype (1840s – 1900s)
Also known as the blueprint process, the cyanotype was first demonstrated by Sir John Herschel in 1840. Based on the light sensitive properties of iron rather than silver salts, the emulsion of ferric ammonium citrate and potassium ferricyanide is coated on cloth or paper, and processed simply after exposure by washing it in water to remove unexposed emulsion. They cyanotype is stable and long lasting, with the characteristic blue colour seen for so long in architects' and engineers' offices.

Ambrotypes (1850s – 1870s)
'Collodion positive' is the technical term for this process and until recently was applied to positives on glass made by the collodian method (the American name ambrotype has become more popular of late). Ambrotypes were made from about 1852, after the introduction of the *wet collodion process*. It was found that a collodion negative, developed in an iron developer and treated with a bleaching process, would appear as a positive image when viewed by reflected light against a dark ground. The method was quickly adopted by photographic studios everywhere to produce a cheap version of the daguerreotype. The glass was produced in similar sizes, with a cover glass pressed against the plate. Behind this image was a piece of black velvet or paper, causing it to appear positive.

Collodion Wet Plate (1851 – 1880s)
Announced by Frederick Scott Archer in 1851, the wet collodion process was faster than the calotype and enabled photographers to produce negatives on a glass base, free from the grainy texture of paper negatives. Collodion, a tensile, sticky substance, nitrocellulose dissolved in ether and alcohol, is applied evenly to a glass plate which is then sensitised by a silver salt solution. The sensitised plate, while still wet, is exposed in the camera and then developed immediately in a separate bath before it can dry. Despite its disadvantages, necessitating the transportation of a darkroom to wherever a photograph was to be made, the collodion process quickly supplanted both calotype and daguerreotype.

Albumen Print (1850 – 1890s)
The most characteristic form of printing in the 19th century, especially when used in conjunction with the wet collodion plate. Introduced by Louis-Désiré Blanquart-Evrard in 1850, the paper was coated with a layer of albumen (processed egg whites) that gave it a glossy, smooth surface. The coated paper was then sensitised with a chemical solution. Prints were made by direct contact with the negative, usually collodion. Albumen prints are characterised by a soft, yellow tonality, and exhibit a wide range of contrast and precise detail.

Gelatin Dry Plate (1880s – 1930s)
In 1871 Richard Leach Maddox suggested that gelatin might replace collodion as the medium for photographic emulsions. Unlike the collodion wet-plate, gelatin emulsions were usable when dry, and in addition, needed much less exposure to light. By the early 1880s the dry had almost completely superseded collodion wet plates for making negatives.

Gelatin Silver Print (1880s – present)
The standard 20th-century black-and-white photographic print, consisting of paper coated with silver halides in gelatin. Introduced in 1882, gelatin-silver, or silver prints, had

virtually replaced albumen by 1895. The gelatin-silver family is a broad one, including silver chloride and silver chlorobromide, and the most popular in use today, silver bromide papers.

Printing-Out-Paper (1880s – 1920s)
Printing-out-paper produces a visible image upon exposure to light, without any chemical development. POP was one alternative successor to albumen, which was also a printing-out rather than developing-out paper, but was gradually made obsolete by silver bromide and other gelatin-silver papers. A printing-out paper is still manufactured, however, by Eastman Kodak, and is enjoying a certain vogue.

Film (1880s – present)
A flexible, transparent support coated with a light sensitive emulsion. The combination in the late 1880s of gelatin emulsion and roll film led to the development of small, hand-held cameras, the widespread use of photography by amateurs, and the growth of the modern photo processing industry.

Platinotype, or Platinum Print (1870s – 1930s)
A platinum print is one in which the final image is formed in platinum. Patented by William Willis in 1873, commercially coated platinum papers were available until 1937, when the increased cost of platinum made the process impracticable. The process employs light sensitive iron salts that during development cause a metallic platinum precipitate to form the image. Platinum prints are distinguished by their extremely long tonal scale. They are much more permanent than silver prints.

Oil Pigment Print (1890s – 1920s)
An image consisting of pigment suspended in gelatin. Like other pigment processes, oil prints rely on the hardening of bichromated gelatin upon exposure to light. After exposure, the print was washed in water, which penetrated the paper in proportion to the softness of the gelatin. An oily pigment (of any colour) was then brushed or rolled on, penetrating in inverse proportion to the amount of water absorbed by the gelatin to produce the image.

Gum-bichromate Print (1890s – 1920s)
Based on Poitevin's patent of 1855 (see Carbon Print), a gum bichromate is formed of pigment, such as watercolour

dyes, suspended in gum arabic sensitised with potassium bichromate. When exposed to light, this emulsion hardens according to the light intensity and is made permanent by washing away the unexposed and thus unhardened areas. Such a print can be made in any single colour or combination of colours by recoating and re-exposing the paper.

Bromoil Print (1900s – 1920s)
Bromoil prints resembled oil prints, but unlike them were not limited to printing by contact, and could be enlarged.

Gum Platinum Print (1900s – 1920s)
A gum platinum print consisted of a combination of two processes, the gum-bichromate and platinum, to render a very rich and subtle impression. The process was not often used, but was much favoured by Edward Steichen, who made some of his greatest images using this technique just after the turn of the century.

Vandyke Brown Print
An early 20th-century process that utilised an emulsion of light-sensitive iron and silver salts to produce a brown image.

'Kwikprint' Print
A contemporary commercial photographic process originally designed to produce proofs for printers. Kwikprint emulsion contains pigments and can be coated on paper or cloth. It produces an effect similar to a gum-bichromate print, or, if used with colour separation negatives, a full-colour print can be made.

COLOUR PROCESSES

A number of experiments were made in the last half of the nineteenth century to make full colour prints. The Ives colour process and the photochrome, or Vidal process, were early attempts, but the autochrome process was the first to be relatively popular.

Trichrome Carbro or Colour Carbro Print (1920s – 1950s)
A carbro print is a carbon print made from a silver print in contact with a specially treated carbon tissue. A trichrome carbro is a colour carbro, made from silver prints made from three colour separation negatives contacted to colour carbon tissues in the three primary colours. The carbon images were then transferred on to a final paper support, in

register. The carbro process has been almost totally superseded by the dye transfer process, but is regarded as perhaps the finest of colour processes. The *Fresson* process is a variation of trichrome carbro.

Dye Transfer Print
Dye transfer prints are made from three separation positives, or matrices, which are gelatin relief images that soak up dyes in proportion to the thickness of the gelatin. The dye-soaked images are transferred in register on to another sheet to reproduce the original colour image.

Type C Print
Type C is a generic name for modern colour prints. The name derives from Kodak Ektacolor Paper Type C, which dominated the colour-print market for many years. Colour sensitive layers in the colour paper, each responsive to a different segment of the colour spectrum, respond proportionately to colours in the negative or transparency. Development produces layers of superimposed colour which appear as a full-colour image.

'INSTANT' PHOTOGRAPHY

In 1947, Edwin H. Land introduced his Polaroid Land process, in which full print development of the image takes place within seconds after exposure. Negative, positive, and developing chemicals are squeezed together by rollers in the camera. Kodak entered the instant-photo market in the mid-70s, with their own brand of instant-picture cameras and film.

PHOTO-MECHANICAL PROCESSES

Photolithography (1850s – present)
Photolithography is based on the mutual repulsion of water and fatty substances (in the shape of a greasy ink). The parts of an image exposed on a plate's light-sensitive coating attract or repel ink depending on the amount of light exposure each has received. A direct method was developed by Niepce, before the invention of photography. Niepce's method was adapted during the 1850s, in France, by Lemercier, Lerebours, Barreswil and Davanne, and then by Alphonse Poitevin.

Photogalvanograph (1850s)
Photogalvanography is an early process, invented by Paul Pretsch in 1854. Somewhat like a primitive version of

photogravure, the prints have a rough, attractive quality.

Phototype (Phototypie) (1850s)
Phototypie was the name given by F. Joubert to the method of printing he derived from the principles contained in Poitevin's patent of 1855 (see *Carbon Print*). Gelatin chromatised with various chromium salts was spread upon a metal plate and exposed to light. Those parts exposed to light hardened, the rest was washed off. The hardened part of the gelatin adhered to the plate, which could be inked directly and printed.

Carbon Print (1850s – 1910)
Based on Poitevin's patent of 1855, the carbon print was perfected by Joseph Wilson Swan in 1864. Carbon tissue (paper coated with gelatin and carbon) was sensitised with potassium bichromate. Exposure under a negative selectively hardened the gelatin in proportion to the amount of light reaching it. The image on the tissue was then transferred to paper.

Woodburytype (1860s – 1880s)
The Woodburytype was developed in 1865 by Walter Bentley Woodbury. A gelatin mould of an image was prepared in which the deepest parts of the mould were to be darkest in the print. This mould was made by a method similar to carbon printing. The mould was inked or covered with pigmented gelatin, and printed in a handpress.

Etched Daguerreotype (1840s)
An early photo-mechanical process in which the printing plate was made out of a daguerreotype directly. Acid etched the exposed silver to produce a plate from which paper prints could be made.

Photoetching (1840s – present)
Photoetching is a term for photomechanical methods of reproduction using an intaglio metal printing plate produced by etching the plate in acid, when the image is formed on the plate by the direct action of light through a negative or transparency upon a sensitive coating which acts as a selective barrier against the acid during printing.

Photogravure (1870s – 1920s)
The photogravure is perhaps the finest photomechanical reproduction process. The process, utilising Swan's carbon tissue, was evolved by Karl Klic in 1879. In earlier days, especially in France, a similar method was known as *heliogravure*. A copper plate was sandwiched with a carbon tissue and then chemically etched to different depths in proportion to the light values in the original print. The etched plate was then printed on a copperplate press.

Collotype (1860s – present)
Another technique based on Poitevin's patent of 1855, the collotype was perfected by Josef Albert in 1868. Similiar processes include the phototype, artotype, albertype, and heliotype. A coating of bichromated gelatin is dried to produce a finely reticulated (wrinkled) surface. The image is exposed on the gelatin, which hardens in proportion. The plate is then inked and transferred to paper.

Halftone (1870s – present)
The halftone was a crucial development in photographic reproduction, leading to truly widespread dissemination of photographic images because it enabled them to be printed on the same press as ordinary raised type. Patented by Frederick Eygene Ives in 1878. First the image is rephotographed through a screen of fine crosslines that converts the continuous tones of the original picture into a pattern of tiny dots that are larger and closer in dark areas, smaller and farther apart in light areas. The dot-pattern image is then chemically etched on to a printing plate, which is then inked to transfer the image to paper. In duotone printing the halftone image receives two press runs. The first published halftone appeared in the New York *Daily Graphic*, 4th March, 1880.

Xerography
A generic term which has come to be used for any kind of image produced by means of office copy machines.

TECHNIQUES

Photogram
A cameraless photograph, in which objects are placed directly on a sheet of photographic paper. After a brief exposure to light, the imprint of the object, solid or translucent as the case may be, is left as an image. This is one of the earliest forms of photography, seen in the *photogenic drawing* experiments of Fox Talbot. It was also popular with some of the experimental artists of the 1920s and 30s, under varying names, such as the *Schadographs* of Christian Schad, or the *Rayograms* of Man Ray.

Cliché Verre
A glass plate is engraved, painted or drawn upon, or stained and smeared with photographic chemicals or other agents. The plate is then used as a negative to make a photographic print in the ordinary way.

Combination Photograph
A photograph in which different images are combined. This may be done in the camera, by multiple exposure, or in the enlarger, by sandwiching and combining negatives.

Photocollage
Photographic and other imagery is taken from varying sources and combined on a sheet of paper to form an image. If it is desired to make a duplicate of this image it can be photographed and printed in the normal way. The photocollage is distinguished from the combination print by the fact that the collaged elements are brought together manually, whereas in the latter process they are combined mechanically in the camera or enlarger.

Sabattier Effect
A partial reversal of tones caused by re-exposure to light during development of film or paper. Named after Armand Sabattier, who, in 1862, described the effect. Often termed solarisation, though strictly speaking, the two are different.

Contact Print
A print that is made by placing a sheet of sensitised material in contact with a negative, then passing light through the negative to expose the material. A contact print is therefore the same size as the negative. Contact printing is desirable when the photographer demands a print of maximum quality.

Enlargement
A print larger than the negative, made by projecting a magnified image of the negative on to a sensitised material. Today's small cameras make enlargement a necessity, but image quality is lost for every degree of enlargement.